# *Most Beautiful*

A collection of poems, prose, and paintings
inspired by the village of Glen Arbor, Michigan
and the Sleeping Bear National Lakeshore,
voted "Most Beautiful Place in America" in 2011.

Poetry & Prose by
## Elizabeth S.E. McBride

with Artwork by
## Connie Cronenwett

A Publication of The Poetry Box®

Cover Art: "Above Pyramid Point" by Connie Cronenwett
Editing & Book Design by Shawn Aveningo Sanders
Cover Layout by Shawn Aveningo Sanders

ISBN: 978-1-948461-35-1
Printed in the United States of America.

Published by The Poetry Box®, 2019
Beaverton, Oregon
ThePoetryBox.com

*Both Connie and I give great thanks to the Glen Arbor Arts Center and its members, who continue to put their passion for the arts into generous action. And to our friends and family: Your love and support have been steadfast sources of encouragement and motivation. Thank you for believing.*

∽

*And special thanks to my friend and mentor, Jack Ridl, and the Landscapes of Poetry group, for the brilliance, inspiration, and compassion you each so willingly share.*

∽

*Warm thanks to John Lilley, photographer; to Jeannie Ballew at EditProse, for connecting Connie and me; and to Shawn Aveningo Sanders, for making dreams become a beautiful and tangible reality!*

# Contents

## *Artwork:*

# Introduction

In August of 2011, Sleeping Bear Dunes National Lakeshore and the surrounding region were selected as a "Most Beautiful Place in America" in ABC's Good Morning America online competition to name the "Top Ten Most Beautiful Places in America". Since then, the designation has brought tourism from around the world, and continued to highlight the beneficial work of those who have worked to preserve and protect the natural beauty of this region.

In May of 2013, I was given the opportunity to serve as artist-in-residence in Glen Arbor, Michigan, by the Glen Arbor Art Association (now the Glen Arbor Arts Center). This is a unique time of year when the village prepares to welcome the new tourist season and the return of seasonal residents to this wonderland between beautiful Glen Lake and awe-inspiring Lake Michigan and the National Lakeshore region. This collection of poetry and prose is a reflection of an exploration into the amazing landscape, history, and culture of this region, and the experience of being its witness.

My heartfelt thanks go out to the Glen Arbor Arts Center, the Sleeping Bear Dunes National Lakeshore Park Service personnel, and the Glen Arbor community, all of whom welcomed me and my unending questions about the science, history, mystery, and beauty of this extraordinary place; and to my friend and October 2013 GAAC artist-in-residence and painter, Connie Cronenwett, who so aptly portrays this "Most Beautiful Place in America."

Elizabeth S.E. McBride

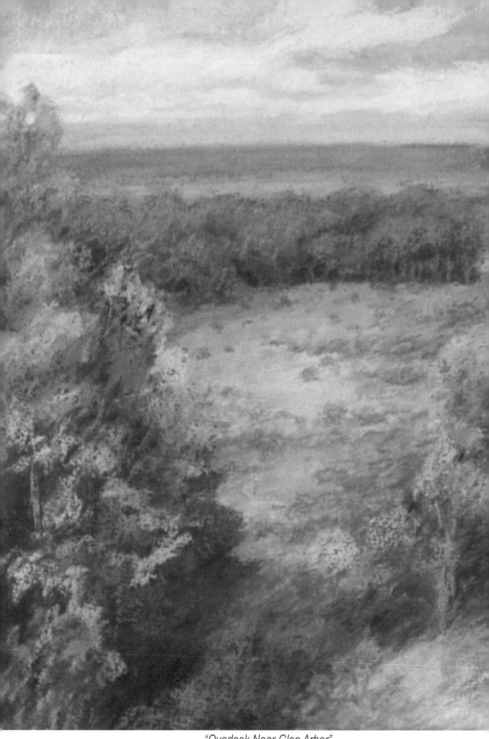

*"Overlook Near Glen Arbor"*

# Most Beautiful

Is it in omniscient views
that part the curtains of horizon?
In the sculpted, regal mounds
of lifted history at your feet?

Is it in the majesty
of lofty, shaded, leafy awnings;
in clear streams that chirr with hurry
to join waves and break on shore?

Is it in the twig that holds
the lilac panicle aloft,
the brush of sunlight on the hilltop
skimmed with green as morning comes?

Or can it be in arched, dried canes,
in wisps of disappearing clouds,
in the slit of sunset fading;
corals fossilized to stone?

Can it be in billowed grasses,
seagull footprints at the shoreline,
lichen-covered curls of birch bark,
dewdrops caught in fallen leaves?

Is it in the full, wild silence
of the woods, when, clothed in stillness,
self recedes and joins the trees
in their hallowed repose?

Wherever there is wonder, there
beauty waits to be discovered,
speaking first from deep within,
teaching us to see.

# May Evening Walk in Glen Arbor

A cool wind blows from the Big Lake.
The ground exhales its warm, moist breath
and suddenly the spring has come—
the village greets the season's change.

Walking Lake Street, one can see:

> Smiles of merchants readying summer,
> bikers, walkers, dogs on leashes,
> strollers savoring the day.
>
> Signs describing ice cream flavors,
> pots of flowers awakening doorsteps,
> adirondacks painted bright.
>
> Glistening whorls of grey-green White Pine
> rising, waving in the breezes;
> marsh marigolds around their feet.
>
> Light on upturned trillium faces,
> flowered hillsides, weeping willows,
> woodpecker's hewn honeycombs.
>
> Roadsides lined with last year's pinecones,
> sun that lights Glen Lake to rival
> the Caribbean's marine blue.
>
> Cedars knitted into shadows,
> leaning toward the rippled lakebed,
> pavement that gives way to sand.

Then, turning back, the Big Lake drums
its waves against both sand and stone.
Pines hush rumors of a storm.
Jays are calling.

> Sunset lingers.

Artists unload stacks of paintings
for the galleries to hang.

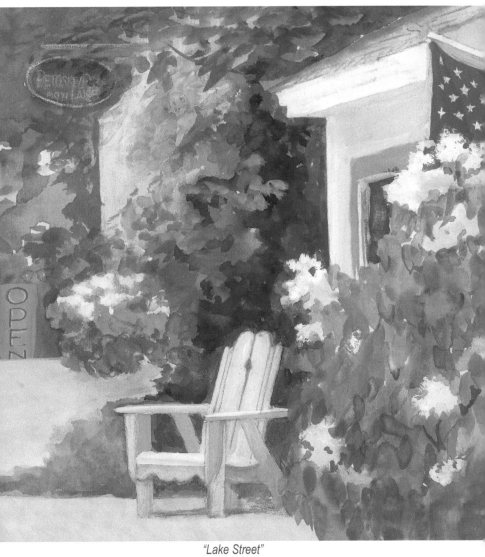

*"Lake Street"*

# Spring Rain on the Heritage Trail

All alone
on Heritage Trail
with glowing mosses
at your feet,

the slow mists rise
and hover near
the budding backlit
canopy.

The slightest breeze
plays symphonies
of raindrops sprung
from weighted
leaves.

From every height
a wash of sound
showers to
the forest
floor.

The hush
returns
and in this place
of perfect
stillness,

one

is

a

crowd.

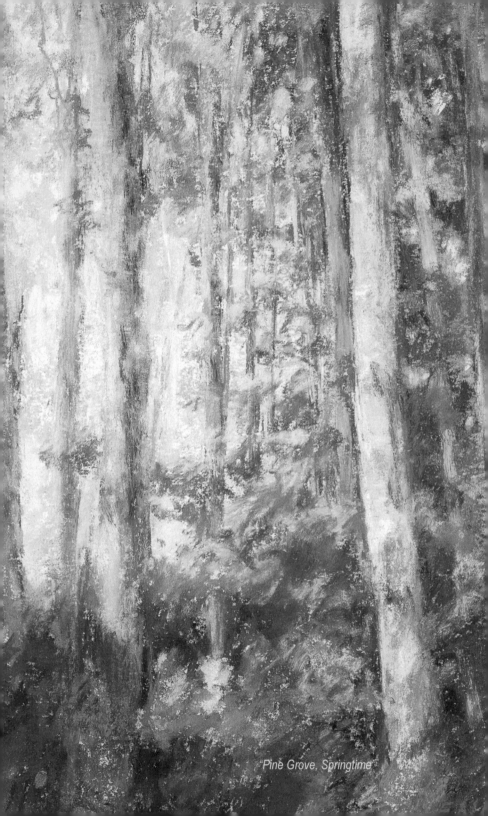

"Pine Grove, Springtime"

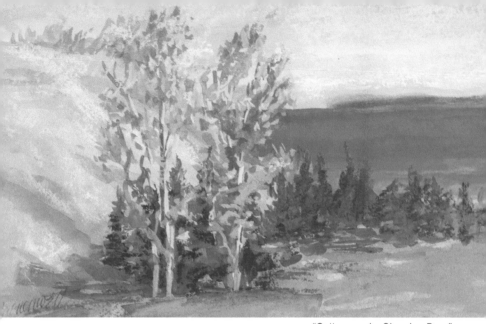

*"Cottonwoods, Sleeping Bear"*

## Walking the Strand Again

Yesterday I walked this shore. Today it is the same and new. "RUSSEL" is remembered here, his unfinished name faltering in the sand, accompanied by a hasty "TIM," and a joyful, giant "HI!"

A small cache of rocks is clustered near the waterline. I'm tempted to participate in this sacred northern pastime; adding to the gathering of oblong, multi-colored treasures.

Indifferent to its visitors, the shoreline takes and gives its gifts. I retrieve a piece of jasper and toss it back into the water. How long had it taken to achieve its escape from the beating waves? How long will it take to climb to the waterline again?

Strolling now, I pick through what the lake has not erased from the early tide, this morning's

visitors, yesterday, and traces of former centuries: a sandcastle, a fresh stick-drawing, feathers, footprints, tangled strands of beach grass, driftwood, clamshells, glistening rocks, fossilized corals, and small bits of bone.

We are the newcomers here. The stones we 'discover,' tumbled their way through years of travel on ancient lakebeds, or maybe they were left behind by melting sheets of ice. I sift them through my dripping fingers; a jumble of present and distant past.

The strand is the bone-pile of the lake, stacked and layered by the waves. Its remains lie broken, polished, rounded and gleaming in the springtime sun. I wonder if I'm walking on the last remains of mastodons, gemstones carried from afar, or hand-hewn tools and fishing spears?

The lake answers with one more wave. The dune sheds sand into the back-blow. Everything continues in its wearing away, becoming new—just as it has always done.

I bring home a feather.

*"Piping Plover Feather"*

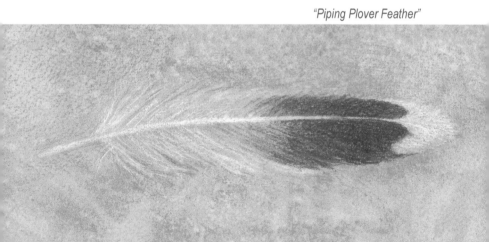

# On the Roof of the Life-Saving Station Boathouse: The Preservationist Speaks

*In honor and gratitude for the work of Historic Preservationist,*
*William Love, and his crew, May 2013.*

From here I can usually see both the Manitous, the sandy crescents of their smiles pale in the early morning light. Hand-split shingles in my left hand; hammer in the right, I pause and peer into the layered blanket of fog that shrouds the waterway and islands.

Sixteen more wedge-shaped cedar pieces will complete the "witches hat" that sits atop the boathouse here, at the old Life-Saving Station. Each shingle's measured, cut, and painted, before it's carried up to be installed. "You only have one chance to do it right," I've told my crew, "from here on out, your work will be repeated as the authentic way things were done." This same shade of red has always been used to keep the station visible from far offshore.

On these whispery pre-spring days, when I'm up here mending the roof, I think of the fogs and storms it's seen, and the lives lost in these changing waters. This station is a place that knew hard work, but rang with the laughter and friendship of the crew that lived and worked here, and the officers' families that lived here too.

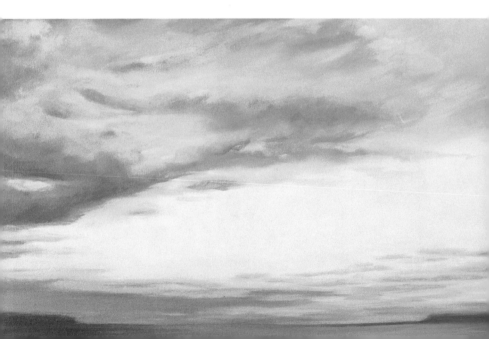

And this is a place that knew the Lake's terror; the sound of groaning wheels moving lifeboats forward on the iron rails, the crash and thunder of breaking waves, the heavy wooden doors of the boathouse thumping in the gale force winds, …and the loudest silence known to man, the overwhelming hollow of a rescue defeated.

Years ago the drip line around the officer's house was completely set with colored lake stones. Each stone stands up on its end, a small memorial to the hands that plucked it from this northern sea. Who would have placed them there, I wonder? That story still wants to be told. There are so many stories here. And every day I work to keep the touchstones of those stories true.

This roof is closer to the wildness of this place than the land below, where paved sidewalks and tiled markers guide both footsteps and perspectives. The sky and surf are always changing—yet in some ways, they stay the same.

Voices of the distant past mingle with the calls of gulls. The lonely foghorn groans and  signals on this nearly sightless day.

Vigilance is preserved.

*"Early Light, North Manitou Island"*

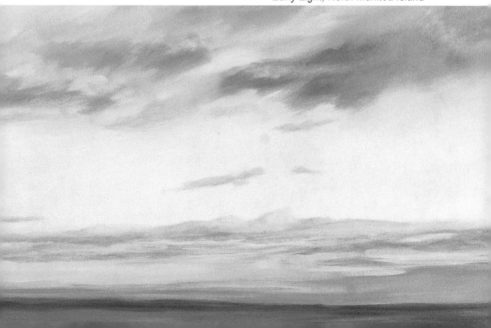

# Boulder Along
# Pierce Stocking Scenic Drive

I almost overlooked it there,
so nondescript it was, and squat
among tall perfectly straight trunks
damp-dark from rain, and gold-swept by
the bloom of early springtime sun.

Shrouded in moss, it blended in
to May's clear glow of brimming green.
What is it doing here? And how
long has it waited; mute—while lichens
climb its bowed and burdened back?

Before the hardwoods and the vines,
before the birches, evergreens;
before dune-building eastbound winds,
it settled on this rich moraine;
newcomer from another time.

Now, a stone's throw from the road,
the asphalt curb and yellow line,
this boulder loosened from the grasp
of ice thousands of years ago
recalls a sea we'll never know,
dreams inlands it will never see.

*"Rock in the Trees"*

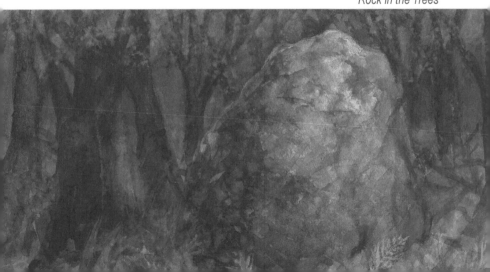

# Nest of Gravel

Why does the piping plover choose
a nest of gravel for her young?

Would the ease of moss and feathers
lure them toward a life of comfort,
hardly showing them the harshness
of the fickle shoreline's ways?

Do the hours amongst the rocks
saturate her with their palette
until her eggs are camouflaged—
brown-speckled, smooth, and grey?

Does she ponder and compare
her Great Lakes home with Gulf Coast shorelines:
deep-north blues with sun-bright turquoise,
rushing waves awash with pebbles;
sizzling foam against the sand?

Does she tell her four small chicks
what she recalls of last year's flight,
whispering, "We must all get ready…
rest now, surely soon we'll go,
before the coming storms."

---

*The piping plover is an endangered shoreline bird that nests along the beaches and coastlines of Lake Michigan and the Atlantic Ocean. The small birds lay their eggs among rocks and pebbles on the beach, where they blend in well with the stones and sea grasses of the shoreline. Piping plovers are migratory birds that fly to the Gulf of Mexico. The Audubon Society has declared the birds to be on the brink of extinction. (www.fws.gov/midwest/endangered/pipingplover/piplnewpage.html)*

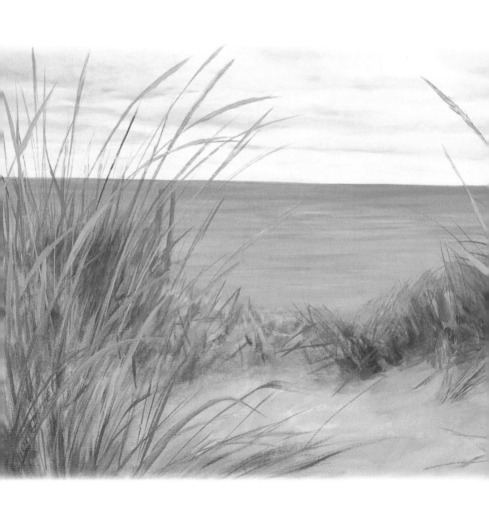

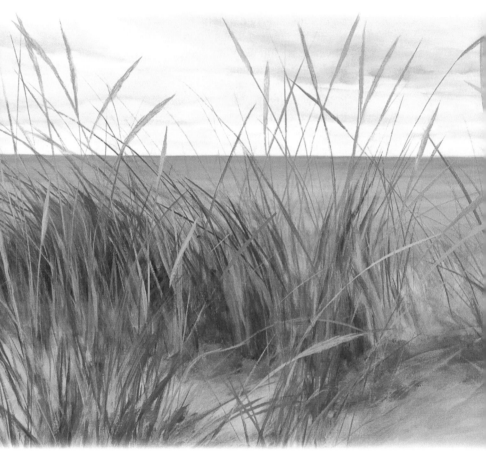

*"Empire Beach"*

# Imagining Glen Haven Waterfront

Park beside the red Museum,
and strive to see what used to be here,
before the cherry cannery:
a warehouse and a busy port.
Envision a long wooden dock
stretching over rolling waves,
tramcars rumbling its full length,
laden with steep stacks of wood
to feed the steamships drawn to port.

Now listen for the calls of deckhands,
horses' hoof-beats, wagons trundling,
pulling freight across its planks.
Hear the slap of oars to waves
as fishing boats are leaving port.
Watch the chase and splash of children
playing in the rolling surf,
clothed in heavy bathing costumes;
families picnicking on the sand.

Breezes mingle smells of fish
with breads baking at the Inn,
the sweat of foremen who have come
to sell logs and buy kerosene,
or have the blacksmith mend a harness,
fix a hinge, or weld a chain.
Saws that sever blocks of ice
ring from D.H. Day's Ice House
out behind the General Store.

Watch the Fresnel cast its beam
across the passage Manitou,
while the buoy bell rings its pleas
matching to the swells and troughs
that span the distance from the port.
The waterfront has come alive
out of what it used to be,
out of dreams that did not die
even when steam engines did.

~~~~~~~~

Now bikers emerge from the Heritage Trail.
They stop at the store for bottled water.
Tourists park and ask for postcards and DVD's about the Park.

~~~~~~~~~

The clanging from the blacksmith's stops.
The voices of the children cease.
Barns recede into the mists, the dock
is gone, the ships have sailed.

~~~~~~~~~~

Lake, breezes,
            scents of evergreens,
                        and the sounds of seas remain

~~~~~~~~~~

while gull-capped pilings
                reach up, empty-
                            handed from the waves.

~~~~~~~~~~

Inside the museum,
someone rings the buoy bell.

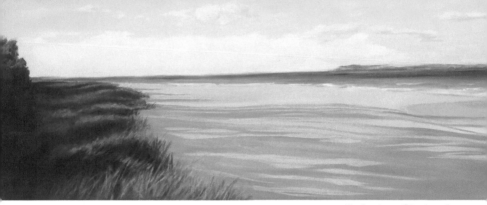

*"Lakeshore Shadows"*

# Daybreak at the End
# of Port Oneida Road

The fog is thick.  The morning drips with green and
shadow.  This is a beach on Lake Michigan, yet it's
each Great Lake

> and every spring,
> and any year.
> Time can stand still.

Placing each footfall neatly on roots that form a
staircase to the beach, I reach for a handhold in the
overhang of cedar-scented elbows. What feet have
followed this steep path before me? What hands
have grasped this polished branch, and pressed
back to lean against the stones that line the path of
my descent?

The shoreline waits to be revealed and only murmurs in its waking. Silver swells pull from the grey that is still this invisible sea, and swirl their liquid rhinestone collars round the backs of submerged boulders, chunks of granite, banded jasper, basalt, limestone; mysteries carried many miles and set here in a different time.

At the water's edge I stand, peering into the muculent gray, searching for the horizon line. I pause to watch the elusive swirls, where long ago, a glacier paused, leaving these silent stones behind in its slow retreat.

*"Dune Near Lake Michigan"*

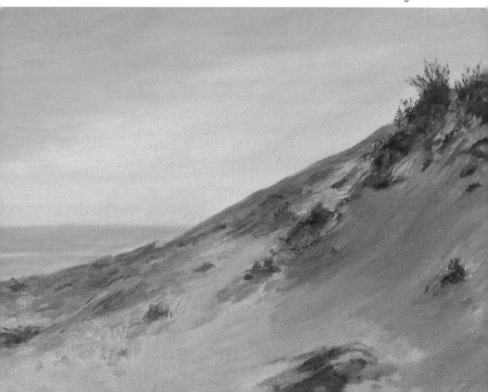

# More Than What You See

They're just an attempt—the paths and trails, drives, overlooks, and roadside stops; just an attempt to let you guzzle, sip, and swallow the magnitude of Sleeping Bear Dunes. You can't.

Perhaps you could garner an impression of their height by a climb to the top, and a view of the sheer drop to the distant turquoise shoreline far below. Or maybe, if you donned a backpack, armed yourself with water and sunscreen, and set out to hike to find their distance, you'd discover the wonder of their scope. Yet, among the disorienting mounds and hills and troughs that appear between trail markers and amidst the neat progression of plant life that signals distance from the shore, the challenges of marking paths on moving landforms becomes apparent. And every time you return to discover this wondrous place again—you would find your paths slightly changed.

The Dunes don't sleep. From savage storms that rearrange the terrain within hours, to trickles of sand grains that tumble when a seagull lands and stretches its wings, this is a landscape in constant motion. The perpetual updraft off the lake skims the sand and drops its cargo back behind the newest crest, maintaining the slow transplant of the surface in an ever-spreading sheen; feeding the great Bear as it lumbers inland, inch-by-inch over the years.

Still, the majesty extends beyond the visible. For when, upon the tallest dune, you conjure the image of the massive glacier that gave birth to this formation, carved the Great Lakes, ground massive boulders into powder, and dispensed rock and soil and water in its mounded, seeping wake; the 'big' you see, that writhes around the edges of landlocked perception, pales in contrast to the 'big' that left it her—where you are standing—with its sand inside your shoes.

# At the Top:
## 450 Feet Above Lake Level

Bounding from lake level into the sky,
it is the punctuation of
a run-on, land-bound sentence stretching
far across the Mitten State.

Despite the heat and sand and haul,
the panting, pulling, leaning forward,
all is forgotten when sky and water
merge in a brilliant panorama.

Now you stand on a seabed rolled
and blown into a towering mound.
You're breathing in the rush, the updraft,
revelling in the dazzling light,
the million scintillant ways of blue!

*"Dune, Grape Vine"*

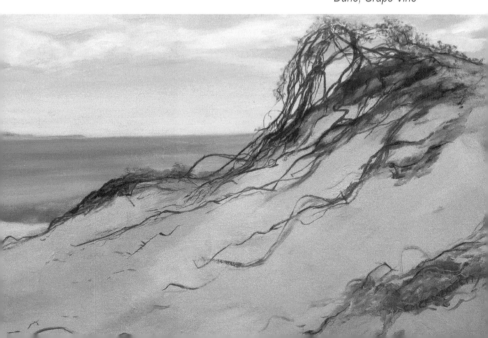

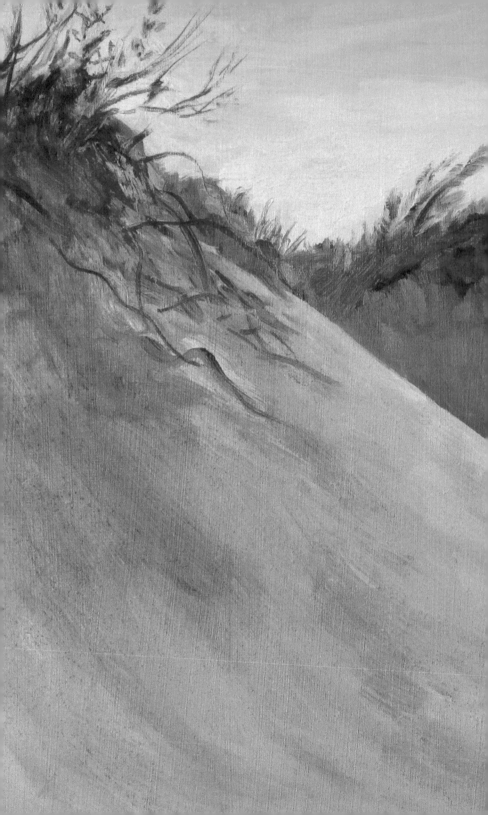

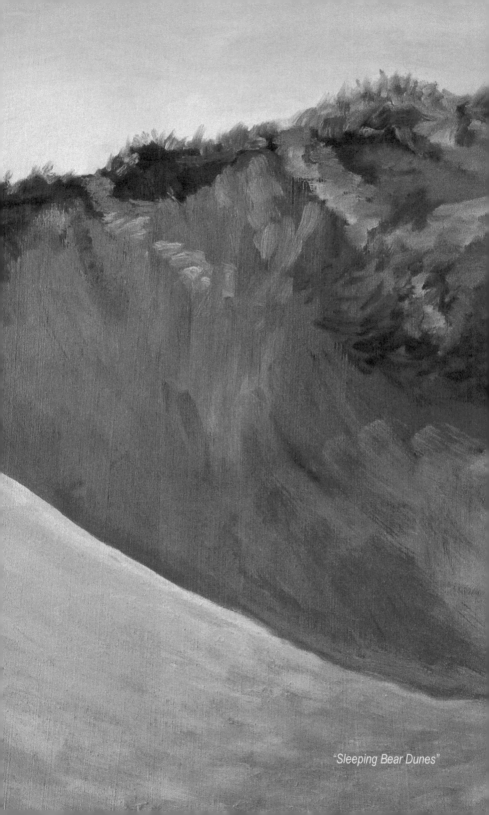

*"Sleeping Bear Dunes"*

# Soul's Harbor:
## Pyramid Point from a Distance

You stand alone as inspiration—
faithful to duty, offering intrigue:
you keep us wondering
what lies ahead, just beyond the turn.

You square your wind-worn shoulders up,
hold the boundaries of shorelines taut,
serve as reference, north or south,
and all without the lofty heights
displayed by your sweet slumbering kin.

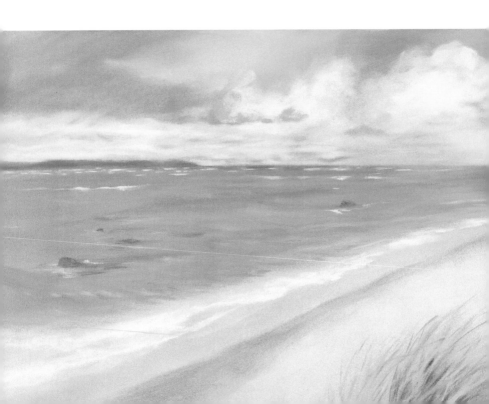

We cling to the resolute image of
your stalwart stance within the blue.
Shrouded by fog, or lit by moonlight,
blistered by heat, or brittle cold,
you turn your face steadfastly toward
whatever comes for you.

*"Looking Toward Pyramid Point"*

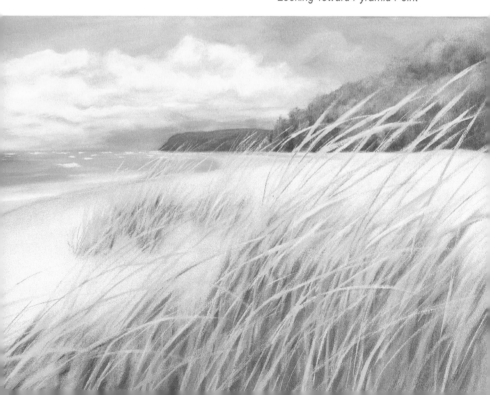

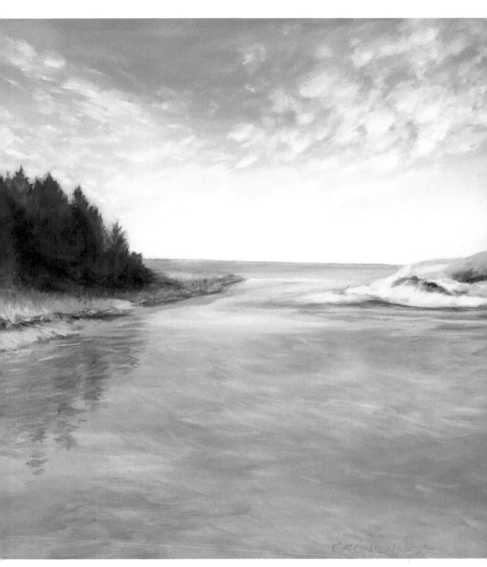

*"North Bar Lake"*

# North Bar Lake Overlook & Picnic Area

Held aloft, over the treetops
on a wood-railed precipice,
viewing forest, hills, horizon,
you look toward the writhing blue.

Thunderous waves and rearing whitecaps
charge the full length of the shoreline,
endless dance of light and contrast
beyond early leaves unfurled.

Spring has brought its best fresh green,
an overlay for winter's cedar,
blue-grey spruce, and ragged jack pine,
frothed with luminous new growth.

Evening sun lights distant sand dunes,
brushing arching sea grass golden,
lights the undersides of leaves—and
sighing, you look down to see,

that you are standing in the place where:

*Nate + Rach; Alex + Laura,*
*Mommy & Daddy Johnson '07,*
*Suzy, Kay, Justin + Sarah…*
among yet a hundred others,

have each paused to capture grandeur
here, at "Overlook Eleven,"

and not knowing what to do
to take it in; preserve the wonder,
hold, and own it any longer
than it takes to turn away—

They simply left their names behind.

# Front Porch at the Charles Olsen Farm

*For Mrs. Hattie Olsen (mother of nine), of the historic*
*"Charles Olsen Farm"*

You must have trod here when you crossed
the maple-bordered lawn,
returning from the roadside, arms
filled with lilac bouquets.

Perhaps you paused on the porch step,
and scanned the rolling, wooded hills,
looking for your sons and daughters
with their backs bent low to work;
and you gave thanks, as you went in.

Behind the house and up the hill,
we see the cistern's cement collar,
a simple rusted pipe protruding
through a mat of last year's leaves.

When your children were still small,
did you pump your water here
and carry it in pails that sloshed
back to the kitchen, to the sounds
of sleepy family rising?

You'd gathered eggs, and fed the hogs,
and leaned your forehead on warm flanks
while drawing down the cows' sweet milk,
and listening to the warble-whir
of swallows in the eaves.

What was it like when this was new:
the fresh-sawn wood,
the new-mown hay,
the tasseled corn,
the breezes lifting
from the murmuring Big Lake?

We come to look at what is left.
We cannot see what you came to,
or see the burden of your days,

the reddened cracks on your worn hands,
the blisters on your calloused heels.

We cannot feel the bone-tired ache
of hours of work, the hollows left
by loneliness, or fears that walked
beside each season's turn.

In the cathedral of the barn,
slender streaks of glittered light
join pierced wooden constellations—
knotholes hollowed out by time.
Nearby, hand-forged iron bands
still hold the aging silo's heights,
stacked one-round-upon-another
toward the ever-changing sky.

This is the farm's own soul and shelter.
It worked you raw and still it fed you,
brought you life just as it spent you,
always yielding green anew,
as if the cycled busyness
could never end,
as if this quiet
would not someday
become witness
to life's larger seasons' spans.

We pause—and listen for your voice
echoing in this silence.
The barn doors catch the wind and beat
your heart's rhythm against the walls,
while rusted hinges sing your joys
and sorrows into woven stories
that we weave into our own.

One purple hyacinth stands alone
in the center of the lawn.
One flower standing still
and reaching
toward the sprawling sky.

You were here.

# Waterfall of Light

Crystal River ripples, flows
and turns beneath bowed evergreens.

Reflections light the undersides
of every branch, and trace their
brindled rugged trunks
with cascades of illusioned rain.

Jack pines hang their draping boughs
over the water, fingers trailing
like the paddler who floats slow
and mesmerized by motion, stillness

becomes both
at once.

# New Song

A vireo sings from the bush beside
a log half-sunken in the stream.

His warbling song flings trills and slides
over last winter's melted snows,

over the flow of everything
that passes always by.

It is the new season always sung—
sung over the old.

"Pine Over Crystal River"

# Unmarked Turnout at Glen Haven

It's just a small alcove along the narrow road, the last ridge of sand before the land breaks to the beach. Outlined by long limbs of driftwood, it hints at the frailty of the narrow habitat between the roadside and the beach.

The winterkilled branches of pine glow auburn in the orange evening light. And you take the narrow path that winds through poplar saplings, where last summer's sand cherry, blackened by winter, stands taut above this year's new beach grass. Ahead, are gaping whorls of weathered junipers. Then the path descends into a cut-through that reveals a brilliant glistening blue.

Walking to the edge, you note a deer was here this afternoon, its footsteps carved into wet sand. A gull cries out and cocks its head, eyeing the waves for darting fish. Down the coastline, the mighty dunes rise hundreds of feet into the air, folding back from this long shore in their slow walk inland.

You look back toward the Cannery, radiating color in its red, re-purposed splendor; an adaptation of the warehouse and the lumber mill that came before. Once it rang with noise and mayhem. Now, used as a Boat Museum, it houses the Fresnel light, the buoy bell, lifeboats, rowboats, and even a 3,000 year-old dugout canoe. The surrounding guesthouse, school, general store, blacksmith shop, and the aging pilings that once held the dock, were built out of dreams and lifetimes of promise. Now they stand as restored reminders of what was once here, and how things can change.

Here, in this common unmarked spot, the evidence of heavy ice sheets, hundreds of years of blowing sands and stormy waves, the harvesting and re-growth of timber, the rise and boom and fall of industry built upon both wood and steam, the development of the Life-Saving Service before the U.S. Coast Guard existed, the claim and protection of our National Shorelines, the re-making of history into education - with parking guided by last year's deadwood; here it is all captured.

Everything this place has been is still found here in some small way. And every visitor, whether tourist from halfway around the world, or townsperson stopping here for lunch, can take some of this long view with them, if not in overt thought, at least, in response to its perfect solitude. The 'spectacular' is relative. The commonplace, when given our attention, never lacks for miracles.

*"White Pine Standing by the Lake"*

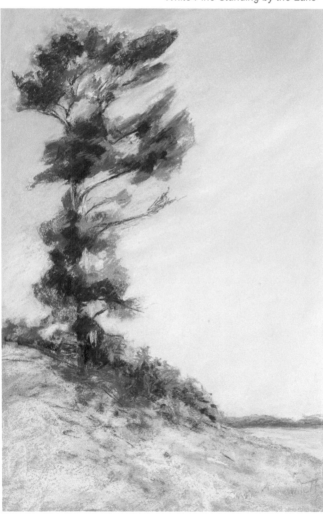

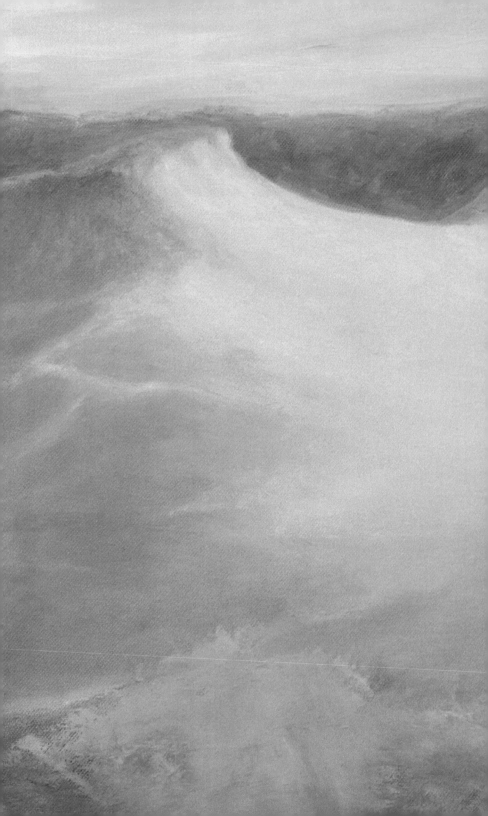

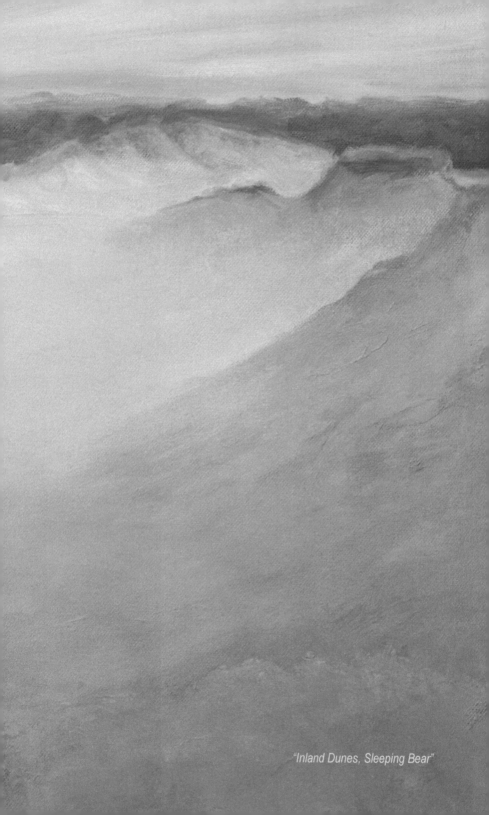

"Inland Dunes, Sleeping Bear"

# Praise for Most Beautiful

In her luminous work *Most Beautiful*, Elizabeth McBride's elegant and earthbound writing creates that uncommon experience only a fine artist can give us: She makes permanent what we experience for but a moment. Her vigilance honors an area honored, but her work goes beyond affirming what we already know: that this area is "beautiful." Revealing what that deeply means, that is the job of the real writer. And McBride is that real writer. Elizabeth McBride gently calls our attention to and gives us the only way we can "be there" when we aren't. "Lake, breezes,/ scents of cedar and evergreens,/ and the sounds of seas remain—" because Elizabeth McBride has made it so.

~ Jack Ridl, author of *Practicing to Walk Like a Heron*
and *Saint Peter and the Goldfinch*

From Lake Street in Glen Arbor, to the footprints along the shoreline at Sleeping Bear Dunes, on the wings of the endangered Plover, or "in the wild silence of the woods" Elizabeth McBride's poems allow us to live more fully involved with what transcends our daily lives. For every question of endangerment, including the human spirit, the land answers. For every wearing away, McBride show us a becoming of newness. The way "The commonplace, when given our attention, never lacks for miracles"—and, indeed, McBride shows us those miracles in every poem.

Glacier history, evidence of the harvesting and re-growth of timber, "the cathedral of the barn," the massive dunes, deer prints, bird song, all are here to honor the awe of what was, still is, will always be— miraculous. What a pleasure, a relief, to experience the stillness of connection these poems and paintings offer.

~ Joy Gaines-Friedler, author of *Capture Theory*

Elizabeth McBride's book of poems is truly a sensory pleasure to read, whether one is experiencing the Glen Arbor area for the first time or for a lifetime. Glen Arbor in the Sleeping Bear Dunes National Lakeshore has been identified in a Good Morning America fake news contest as "The Most Beautiful Place in America." It is a well-deserved title, however earned, as one can see in this evocative poetry. From the Prologue to the final poem, McBride takes us on a glorious tour of the area: to the farms of Port Oneida, to the little town of Empire, to the vistas of Pierce Stocking Drive and the thrill of Pyramid Point and its shipwrecks.

In gale winds or calm there is beauty to behold at the lakeshore. The Manitou Islands hold the secret for the ages. We remember the Indian tale of the Sleeping Mother Bear and her two cubs, lost to the storm, but who give us the powerful message of motherly love. Through McBride's heartfelt and warm observations of nature and "found objects" at the lakeshore, we sense her profound love for all things natural from the tiniest pebble, to the piles of shells on the beach, to the helpless piping plovers born on the beach whose feathers she carefully collects.

All of our senses are brought into play in these poems as the author strolls the beaches, writing, looking, listening in wonderment. May you too, bring home a feather.

~ Betsy Wagner, Glen Arbor Arts Center
Artist-in-Residence Program

# About the Author & Artist

Elizabeth S.E. McBride's poetry is often an experience of walking in this world as a careful and curious observer—the natural result of her reverence for the wonders of creation and those with whom it is shared. Her poetry can be seen in the following literary journals and publications: *Dunes Review*, *Louisiana Literature*, *Third Wednesday*, *Red River Review*, *Seeding the Snow*, *Scintilla*, *Poetry Breakfast*, and *Peninsula Poets*. <elizabethmcbridewriter.com>

Connie Cronenwett lives in Dexter, Michigan. She is a landscape painter, working in oil and pastel. When painting, her goal is to go beyond the appearance of a scene, to somehow capture the spirit of a place. She was an artist-in-residence through the Glen Arbor Art Association in 2013. Her work can always be found at WSG gallery in Ann Arbor, MI. <conniecronenwett.com>

# About The Poetry Box

The Poetry Box® was founded by Shawn Aveningo Sanders & Robert Sanders, who wholeheartedly believe that every day spent with the people you love, doing what you love, is a moment in life worth cherishing. Their boutique press celebrates the talents of their fellow artisans and writers through professional book design and publishing of individual collections, as well as their flagship literary journal, *The Poeming Pigeon*.

Feel free to visit the online bookstore (thePoetryBox.com), where you'll find more titles including:

*November Quilt* by Penelope Scambly Schott

*Shrinking Bones* by Judy K. Mosher

*Epicurean Ecstasy* by Cynthia Gallaher

*The Poet's Curse* by Michael Estabrook

*Like the O in Hope* by Jeanne Julian

*The Unknowable Mystery of Other People* by Sally Zakariya

*Impossible Ledges* by Dianne Avey

*Painting the Heart Open* by Liz Nakazawa

*Bee Dance* by Cathy Cain

*Abruptio* by Melissa Fourier

*Surreal Expulsion* by D.R. James

*The Dichotomy Between Light & Dark* by Michael B. Carroll Jr.

and more . . .

CPSIA information can be obtained
at www.ICGtesting.com
Printed in the USA
BVHW090541260919
559452BV00001BA/4/P